Christian Caujolle

JOAN
FONTCUBERTA 55

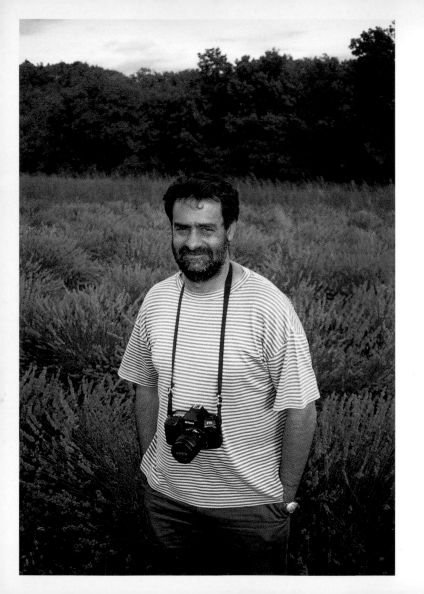

ook out – it's photography, so it's probably false.' So Joan Fontcuberta tells us in
he breath, before adding in the next, 'Look, photography's the truest thing
ere is: the pure imprint of reality.' And with a broad grin, he presents us with
ages that delight, perplex and amaze, making us uncomfortable with our common
nceptions of photography and its supposed ability to communicate an 'objective'
sion of the reality around us. Deploying his admirable grasp of all the medium's
chnical resources, this crafty, humorous Catalan takes a thoughtful, serious
proach to the 150-year-old art. He is interested both in questioning the
ature of photography and in exploring our collective blind faith in the powers of a
chnology that has attempted to substitute itself for direct experience of the
al world.

we are to understand this faith, we must go back to the beginnings of photog-
aphy. Ever since the Renaissance, with the invention of the camera obscura, we
ave celebrated photography's ability to capture the immediacy and, most of
l, the 'veracity' of the image. Until recently, it was thought that photography
roper began in 1839, when the French government bought the inventions of
iepce and Daguerre, and in a burst of that ostentatious generosity of which
nly the nineteenth-century bourgeoisie was capable, 'offered the world the
esults'. Since then, a daguerreotype dating from two years earlier has been
und. Whatever its precise origins, we have assigned to photography the task
f representing the world with all the exactness of which it seems capable, of
eproducing' within a square or a rectangle – using silver salts that oxidize
nder the effect of light – an isolated fragment of that world.

rom landscapes and architectural monuments, photographers went on to
ants, oceans, skies, and then to faces and to historic events. Next, they tackled

the infinitely vast and the infinitely small — distant planets and insects see
under the microscope, the earth viewed from space, and the human body fro
within, or from without through X-ray photography. All this offered what w
might call a 'good likeness' — so astonishingly good, in fact, that anyone wh
looks at a photograph will immediately recognize the original that precede
the image in the three-dimensional world. What is specific to photograph
compared with other modes of representation, is that in order for it to exis
something 'real', a 'thing' (which might be no more than a shadow) that onc
had material reality in space, must, of necessity, have previously existed. Thu
people have assumed that photography bears witness to the real world ar
proves its material existence. We have behaved as if photography, because it
mechanical, were truly objective. But this does not take into account (since w
are always readier to marvel than to analyse) the fact that a photograph is r
more than an artefact, and that behind it there is always an operator, who ha
his or her point of view, subjectivity and sensibilities. Kodak's famous slogan 'Yc
press the button — we do the rest!' has helped fix in people's minds the idea th
it is cameras that take photographs. Photography has fulfilled an old huma
fantasy of appropriating the world by creating a duplicate, perfectly identical t
the original. At the end of the nineteenth century, with advances in technolog
the photograph replaced the gravure and lithograph illustrations previous
used by newspapers. People very quickly forgot that these were reproduction
and — at least in the days when a sense of responsibility on the part of news
paper proprietors was not yet in question — the photo in the paper was assume
to attest to the veracity of the facts reported, and in some sense to authentica
them. Today's press has no apparent difficulty in perpetuating this falsehood; th
habit has taken root, and has become a cultural cliché, making photograph
synonymous with 'truth'.

rom very early on, Fontcuberta wondered why there should have grown
o around photography such a widespread and naive belief in the power
f the image to be 'true', a belief that, being irrational, has become almost
eligious. (The evening TV news resembles a high mass, attended by millions
f devotees of information, on which the image confers the stamp of
ruth.) Fontcuberta has written several texts on this subject, including
e Baiser de Judas (The Judas Kiss), but while his analytical ability and
kill as a writer are undeniable, he has by no means opted for the life of a
heoretician. Though he undertakes a good deal of teaching and lecturing, and
ublishes the magazine Fotovision, he is first and foremost a visual artist.
hotography is the means he has chosen to create his art images, at the same
me exploring the nature of a unique technology that has gradually accumulated
round it a huge number of attitudes, social as well as aesthetic, that border on
e ritualistic.

hat Fontcuberta learned from 1972–7 in the Department of Information
ciences at the Universitat Autonoma de Barcelona was surely influential
the development of his critical approach, or healthy scepticism, regarding
hotography. Added to this was his concurrent employment in the creative
epartment of an advertising agency, where he had ample opportunity to
eflect on the way in which the production and contextualization of images
a process of manipulation, designed to provoke first desire, then the
onsumption reflex' in those who look at them. From the very beginning, he
new that the only reliable information that a photograph can communicate is the
act that it is just that — a photograph. The rest will depend entirely on how it
used. This is why, in parallel with making his visual work, he has always been
terested in exploring related theoretical issues.

A precocious artist, Fontcuberta made his first pictures when he was just eighteen years old, and even then, they were carefully staged. In 1973, he created a 'still life', in which a man deliberately scrapes his finger on a vegetable grater (a painful process evoking both physical and personal experience). It may be worth recalling that in Spain at that time the end of a 40-year-old dictatorship was almost in sight. This would mean the end of isolation and exile for artists and intellectuals, and liberation from the stifling of free expression. Though Catalonia was an exception in the society in which Buñuel shot *Las Hurdes* (*Land Without Bread*, 1932), and had become more open to the outside world with the mass advent of tourists to the Costa Brava, for a young man eager to express himself the atmosphere was oppressive. Only the great painter Antoni Tàpies, a handful of writers and the musicians of the Nova Cançó Catalane spoke, albeit in veiled terms, about creativity and self-expression. There are correspondences between Fontcuberta's early, surrealistic, sometimes mysterious images, and the lyrics of these songwriters, which use word-play to suggest a number of meanings whilst outwitting the censor. What are we to make, for example, of his image of a cyclist (page 21), pedalling vigorously, whose missing legs reveal a wall in the background, while a tennis shoe presses down on the pedal and gloved hands firmly grip the handlebars? Or of a homage to the French artist and writer, Roland Topor, in which a huge snail seems to be mating through a sheet with a young woman in a bedroom decorated with stridently patterned wallpaper (page 23). Do these images represent dreams become reality? Do they suggest that laughter is never far from nightmare? They clearly stem from a distinctive visual culture, whose traditions are very different from those of French, Belgian or Eastern European Surrealism. This is a brand of Spanish Surrealism that is essentially Catalan and which, in Dalí and Miró, represents the best and most universal of the art produced in the Iberian peninsula at that time.

ontcuberta was given three exhibitions in Barcelona and Lleida when he was
ist nineteen. The work he was making at that time was based on collage and
hotomontage, genres with which he was thoroughly familiar and which were
ighly regarded by the *Nueva Lente* (*New Lens*) group with whom he collaborated.
e later analysed and published their work, drawing public attention to the
nportant, but at that time little-known, work of Josep Renau and Nicolas de
ekuona. Without resorting to artifice in the darkroom, he rediscovered the
ense of the bizarre produced by montage through his exploration of space and
is use of photographic manipulation. By cutting up in a particular way – against
ne conventions of realist representation – situations from everyday life, he is
ble to make us smile at the absurdity of expecting photography to be a vehicle
or truth.

n the ferment of Catalonia in the 1980s, Fontcuberta soon established himself
s a leader of a 'school' that was not defined as such aesthetically, but which,
/hen Franco's dead hand was lifted, displayed dazzling creativity. At this time,
n Barcelona and elsewhere, there was a creative explosion in photography,
evealing an extraordinary pool of young talent. Fontcuberta was like a one-man
and – making photographs, organizing exhibitions, helping to plan festivals,
/riting, publishing and teaching. He soon understood that he needed to take
imself outside Spain and quickly forged links with prominent young artists in
iermany, Belgium, France and the Netherlands, where his work was immediately
ppreciated. In 1983, he began an association with the Zabriskie Gallery in
*aris, and in 1984 exhibited at George Eastman House in Rochester, New
ork. Fontcuberta's emergence on the international scene, in keeping with
is intellectual curiosity and his canny strategic approach as an artist, is
uite remarkable for Spain, a country that, despite the wealth of its cultural

life over the past twenty years, is only now acquiring the means of making it contemporary art widely known.

From an early date, Fontcuberta decided to work in series, to carry out project that could be allowed to mature intellectually, the pace determined by th level of funding he was able to raise. Looking at the work he has made over th past twenty-five years, we can see how consistently he pursues his goal, whic is to define in practice the limits of photography and to make us question ou perceptions of it and the role we assign to it. Although he has often rejecte attempts to classify his works, his output can nevertheless be divided int two main groups. First, there are works that employ 'ordinary', even naiv perception, using the medium of photography to tell stories that, though far fetched, become believable through their presentation in tightly structure photographic sequences. In contrast to these are sets of images in which th gap between what is represented and its image is reduced to a minimum: photo graphic 'impressions' that bring us face to face with a disturbing degree-zero c photography. Between these two extremes – the acceptance of photography as way of making fictions, and photography as the raw, but not quite identifiabl trace of an object – Fontcuberta weaves connections that, thanks to his wit an constant exuberance, produce unique and deliberately puzzling work.

Taken as a whole, his art rests on the underlying tension between art an science in photography. When the invention was registered in Paris in 1839, joint meeting of the Académie des Sciences and the Académie des Beaux-Art had to be convened, neither body on its own being competent to define the genre Fontcuberta has a thorough knowledge of the history of photography, and play on this twofold parentage, taking literally the fact that it is both art and science

is interest in science, and especially our conception of it in terms of a belief in progress, is reflected in his love of visiting museums of science and technology, botanical gardens and zoos. In practice, he never fails to make the parallel between the appreciation of science and the perception of photography.

In relation to this, let us look at two series of images, utterly different in form but both belonging to a larger work, 'Historia Artificial'. 'Herbarium' (1982–5) is a set of toned black-and-white prints, mounted in conventional frames, apparently representing a plant collection of the kind found in botanical museums. Subtitled 'Homage to Blossfeldt', after the German artist who, in the 1920s, made a series of prints celebrating the beauty and complexity of natural forms, it is presented with great gravitas under the guise of a new scientific inventory of rare varieties, each with its proper Latin name. It is also possible to see this work as a subtle tribute to early twentieth-century Catalan artists, Antoni Gaudí in particular, whose luxuriant architecture is so often inspired by plant forms.

Nothing could be more apparently 'objective' or scientific than these still lifes, with their simple studio lighting, in which the lens has merely recorded what was put in front of it. However, some of Fontcuberta's plants appear to be afflicted with strange swellings or necroses, and most of them seem to consist of animal rather than vegetable matter. When we look closely (as occurs only too rarely, according to Fontcuberta), we notice that the heart of *Lavandula angustifolia* emerging from the leaves of a member of the cabbage family, is actually the head of a tortoise, seen from below. And if we study the inverted growth of the thorns of a dishevelled variety of rose-dahlia, called *Braohypoda frustrata*, there is no longer any room for doubt. These are artefacts, the ironic bricolage of an inspired fabricator who has constructed his outlandish montages in the studio.

Fontcuberta is playing on the way in which we look at photography. We look at th
forms depicted and try to recognize, or literally 're-know', them. Our eye scan
the image, attempting to make what it perceives coincide with the kinds o
organization of space and mass it has seen before in the three-dimensiona
world, or even in other images, and with whose names and characteristics it i
familiar. We recognize, for example, the shape of a rose, and for every shap
presented in photographic form that resembles a rose, we believe there ha
been a real, pre-existing flower. This is the secret of one of Fontcuberta's mos
successful and delightful pieces of trickery.

In this series, word-play becomes extremely important. At first sight, th
Latin names are every bit as scientific as the photographs. When they ar
read together, however, they form a scabrous Surrealist poem, about se
and human emotions, climaxing in a great peal of laughter. A perfectionist
Fontcuberta gives a great deal of thought to the context in which he places hi
work. He knows that it is this context, as much as what we think we know, tha
creates the meanings we wish to find. In this case, the cultural reference t
Blossfeldt lends an added credibility to the deception, and the ideal plac
in which to install the work is not a museum of contemporary art but th
special exhibitions gallery of a natural history museum. It was therefore onl
natural that Fontcuberta should present the enormous project 'Fauna', whic
he continues to develop, at sites that have included Barcelona's Museu d
Zoologia (1988) and Montreal's Redpath Museum (1990). 'Fauna' works i
basically the same way as 'Herbarium', though the scale is different an
the actual arrangement and installation of the material in space is an integra
part of the project. Its aim is to make us believe that a German scientist-explore
of the mid-twentieth century called Peter Ameisen-Haufen (Anthill), ha

discovered in the course of his expeditions an improbable number of strange animals, including unicorn bats, flying elephants and millipede-snakes. The 'evidence', of course, is that he has taken their photographs. Fontcuberta shows us not only these astonishing photographs (albeit sometimes in poor condition), but also the good Doktor's entire archive, written in a small, neat hand, in black, brown, red or purple ink, his drawings, notes and records, along with some specimens of strange creepy-crawlies that he managed to bring back and preserve.

All is carried out with fantastic attention to detail, and once installed in old-fashioned display cases with the requisite amount of dust, it is more than convincing – indisputable in fact. The Latin names and the pathologically precise descriptions add credence. Added to this is the way in which the prints have aged, the yellow, crumpled paper, the mixture of scientific documents and negatives, the few broken photographic plates, laboratory reports, all in a scholarly muddle. Everything seems authentic, since the context is tailored to the project. This huge, solemn hoax is a perfect example of the care that Fontcuberta takes with the settings for his practical jokes. Expertly manipulating the (objective) fact that a photograph is seen differently in different environments, he takes mischievous pleasure in getting the smallest detail right. But by installing his project in museums with an educational role, he is also telling us something about those mechanisms that promote either science (knowledge and its history) or art (and the history that legitimates it). To present 'Fauna' in a science museum is neither a whim nor a gimmick. It shows an intellectual consistency that, while exploring the nature of photography, also holds up a mirror to the institution that calls it – or ought to call it – into question.

It is in the same seriously playful mode that Fontcuberta invites us to approach his 'scientific deceptions made possible by photography'. They are numerous but we should mention 'Sputnik' (1997), his contribution to the glorious history of scientific progress, and its debt to Soviet supremacy in the conquest of space. In order to tell this tale, which challenges our collective belief in both photography and progress, he becomes the likeable hero of space travel Ivan Istochnikov (a Russianized version of his own name), whose exploits he celebrates in an installation that includes a futuristic spacesuit and a rocket. More poetic is his most recent work, 'Sirens', devoted to the remains of mermaids found by archaeologists in the Digne region of Provence. It includes some superb colour documentation and a brilliant pastiche of an issue of *National Geographic* devoted to the 'discovery', as well as the fake fossil remains, of these fishy Mediterranean beauties. Art and science once again combine in the museum.

In questioning the relationship between photography and reality, Fontcuberta develops – and, of course, subverts – one of the medium's original illusions: the immediate impression as a guarantee of absolute truthfulness. He will certainly be aware of Fox Talbot's 'Pencil of Nature', as the pioneer photographer dubbed his method of taking negative impressions of plants and other objects. Not to mention Man Ray, Moholy-Nagy and Christian Schaad, who invented the 'photogram' (achieved by placing objects on sensitized paper, the object itself acting as a negative). Nevertheless, and regardless of the power of the image, the original object is not always recognizable, and certainly less so than when photographed directly in the studio by a technician whose intention is to reproduce it. This blatant contradiction – that the direct impression of an object seems less 'true' than its reproduction through photography – offered Fontcuberta a rationale for a new series of works.

The first, from the late 1980s, is entitled 'Palimpsests'. Recognizing the eternal popularity of flowered wallpaper, Fontcuberta, with his usual touch of humour, set out to create 'real' flower paper, covering actual wallpaper with emulsion paint and placing photographs of delicate Japanese-style irises and small birds over the corresponding images printed on the wallpaper. The new forms superimpose and substitute themselves for the motifs they ridicule, tone over tone, shape over shape, sometimes revealing inevitable slippages. Since this was well received, he began to create whole design ranges, with names like *Iris Puffs (beige)*, 1992, *Puffs (Special Offer)*, 1992, or *Kleenex Casuals*, 1992, and *Kleenex Boutique*, 1992. The series culminated in the monumental *Iris Germanica* (1992), measuring 100 x 274 cm. This recalls Warhol's interrogation of popular culture, but with one difference: real flowers have been brought into direct confrontation with the imagery of flowers. These palimpsests are both a reflection on taste, and a demonstration of technical virtuosity; exploring the possibilities of photography as much as the everyday uses of the image, and without making a grand statement, they restate the artist's relationship with popular culture. 'Palimpsests' (thoroughly anti-decorative, despite appearances) was followed by the series 'Doble Cos' (Double Body), in which Fontcuberta uses the photogram technique to explore representations of the body. A stereotypical hook-nosed profile of a Jew, for example, is imposed on the Holy Shroud; imprints of hands and erect penises are laid over pornographic images; life-sized bodies are placed over those flayed anatomical figures beloved of medical schools; the lines of a woman's body assume the diagonals of Modigliani's *Femme nue* or Picasso's *La Pisseuse*, before regaining — and subverting — the ideal measurements promoted by the manufacturers of slimming products.

At the same time, Fontcuberta was also creating strange 'frottograms' ('Frotter', French for 'rub') – large, one-off prints with sumptuously rich tones in gradations of green to brown and blue to black – to form animal and vegetable shapes, deconstructing and reinventing them. In creating these works, he used the odd strategy of bringing into physical contact the object photographed and the negative that represents it 'Science Friction', as Fontcuberta might say. It is as if what is real obliterates the matrix of its representation, and by so doing succeeds in endowing it with greater truthfulness. However, we see only distortions or degradations of the image. No matter what aesthetic pleasure may give us, we cannot make the Latin titles (are they culinary or scientific?) for the shapes we see. The only certain thing is that, prior to these images, there existed physical matter.

The most radical expression of this desire to reduce the gap between what is real and its image is the series 'Haemograms', from the late 1990s. Fontcuberta asked his friends to provide him with a drop of blood, which he placed on a glass slide, like a scientist or doctor. But he had no interest in studying or analysing the blood of his friends. His intention was to take their blood (as children do when swearing eternal friendship) and to treat the resulting concretion like the negative of a colour image. It becomes clear that blood is by no means all alike in form; nor is it all red, and it develops cracks when preserved. What is it, in fact, that we see? Abstract forms in all the red shades of the palette, from bright scarlet to brown; simple coloured shapes that, once we know how the images have been produced, also become touching portraits. But given the artist, they could be entirely fictitious. Who can prove that they are not? This challenge lies at the heart of work that constantly questions the notion of 'proof', in terms both of science, where it is rigorously sought, and of photography, where this is far

...om the case. Who can prove, for example, that photographs Fontcuberta ...resents as images made by Picasso, Miró, Dalí or Tàpies are authentic? They ...ay be formally convincing, but they were actually made at the end of the ...wentieth century by a Catalan artist whose medium is photography. In front of ...hese works, one fantasizes about witnessing a dispute among experts, years ...om now, as to whether the portrait of Miró, with his Rolleiflex camera slung ...cross his shoulder, is authentic. Or to see what astronomers at the Paris ...bservatory would make, ninety years hence, of Fontcuberta's 'Constellations', ...hich are, in fact, a photographic record, using a rigorous minimalist process, of ...e traces left on his windscreen by insects that have had an unfortunate ...ncounter with the speed of late-twentieth-century life.

...n one of his most recent works, 'Semiopolis' (1999), Fontcuberta restates his ...entral purpose. In this series, he photographs Braille texts, from the Bible to ...orges, transforming them into mysterious lunar landscapes, pregnant with ...eaning. The world becomes a collection of signs, which we must decipher. ...owever, we can no longer do it, since at this stage of human development, when ...o many multifarious images coexist, we have difficulty in distinguishing between ...xistential reality and its various imageries. We scarcely receive any physical ...xperience of the world without first receiving images that disguise that world, ...hile pretending to reveal it to us and make us desire it.

...oth cheerful and deeply uneasy, serious despite appearances, Fontcuberta ...almly holds out against the clichés of the age. With his surrealist visions of ...e far side of reality, he manipulates his viewers in order to show that under-...tanding must come from experience of the world, not from its images.

Geological Time, Barcelona, 1973. Fontcuberta's early images explore th world's strangeness simply by juxtaposing an unusual situation and an enig matic title. They are traditional in form and cleanly composed, making creativ use of light and shade. Here, the bare words 'Geological Time', in associatic with the stone placed on the chair, provoke questions that the image refuse to answer.

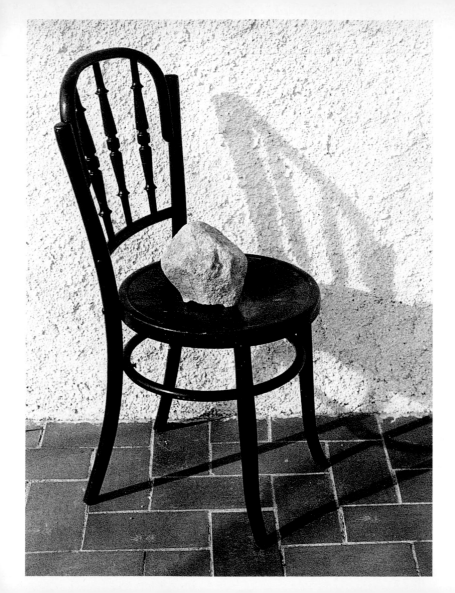

Why Don't You Say It?, Barcelona, 1974. The use of photomontage in the early series is a direct reference to the Surrealist tradition. In this picture, the literal illustration of the phrase 'walls have ears' produces a strange and striking image.

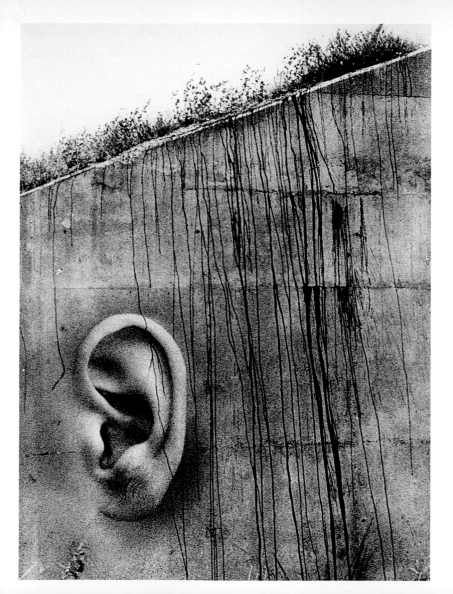

It Was Hard to Be Able to Say: I Am Finally Here, Barcelona, 1975. Th[...] photomontages were made by hand at a time when computers were not yet use[...] for graphic work. The technical difficulty and minute care involved would requir[...] hours of work. This 'self-portrait' mixes strangeness with absurdity in the la[...] years under Franco.

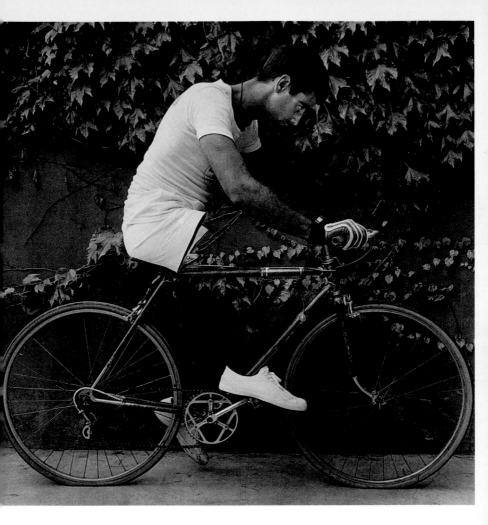

Homage to Topor, Barcelona, 1976. A tribute to the French writer Roland Topor makes explicit the work's Surrealist elements whilst, in common with many of the photographs from this early period, emphasizing the literary. From the start words were fundamental to the conception of Fontcuberta's imagery. It is words that, in or out of step with the image, will draw us into the complicated traps set by Fontcuberta. Here, very simply, they situate the work within a world.

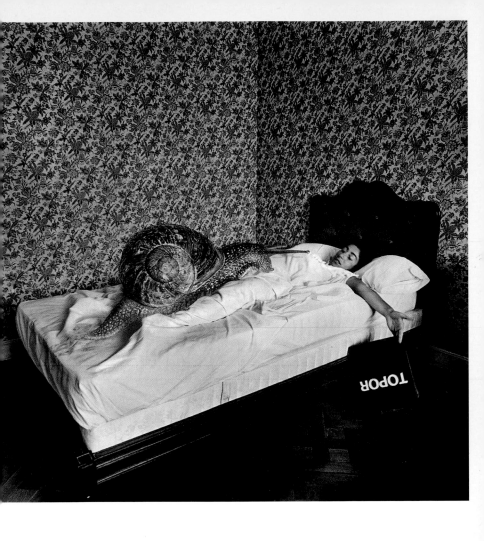

Total Amnesty, Barcelona, 1976. The title allows the spectator to decipher th[e] inscription on the wall, and is a reminder that the piece was made durir[g] Franco's dictatorship. The allusion is at the same time direct and discreet, [in] conflict with the strangeness of the scene and the disappearance of the bit[ch] being covered by the dog. Here, photography transcends the most commonpla[ce] subject matter.

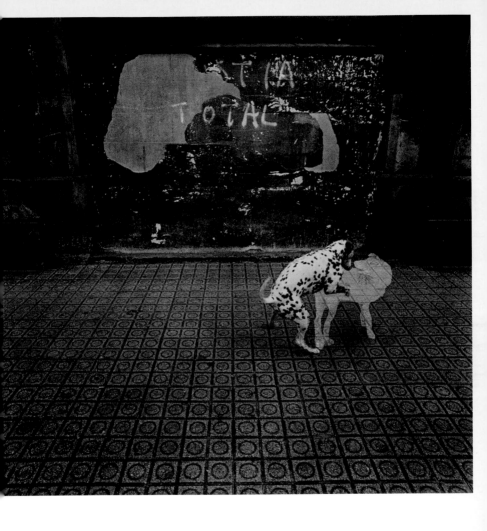

Visitors, Barcelona, 1977. By choosing unusual angles, Fontcuberta accentuate
the strange, in itself Surrealist and sometimes incomprehensible characte
of most natural history museums; by placing their objects in a new contex
according to outdated museographical rules, it makes them seem disquieting
even morbid. The warm tones, like those of old sepia images, create a mor
strongly stated sense of time.

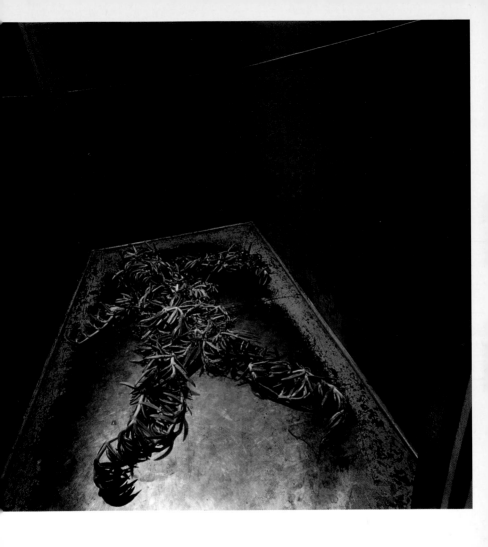

Snake on the Stairs, Barcelona, 1977. This image plays with spatial illusio[n]
An ordinary situation is transformed into one of pure Surrealism, where the wor[ld]
becomes strange and unfamiliar. The stuffed snake seems suddenly to come to li[fe]
and to be slipping — or flying — away down the stairs; for photography can crea[te]
illusions of all sorts. In fact, it consists of nothing but illusions.

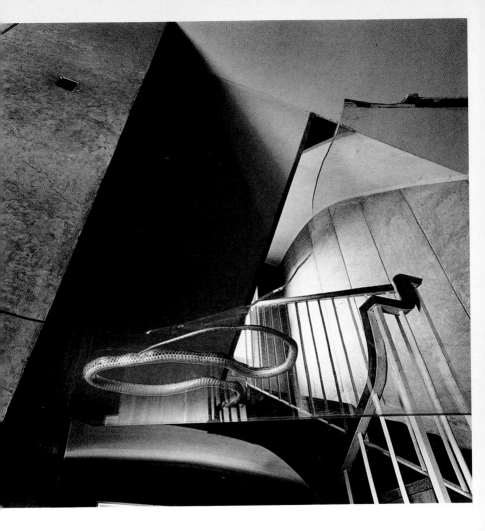

Museu de Zoologia, Barcelona, 1978. The wall-mounted crocodiles are a hilar
ous notion derived from the photographer's view of museums specializing in th
'educational' presentation of the animal kingdom. The composition emphasize
the Surrealist aspect of the exhibit — to create an image that, in actual fact,
never perceived clearly by the visitor.

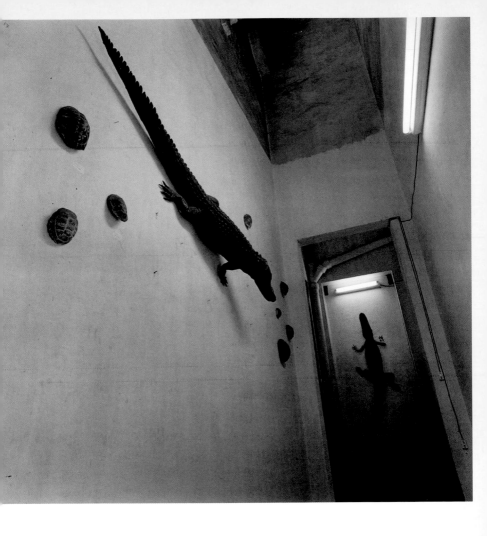

Natural History Museum, London, 1979. Surrealism was famously characterize
by its proponents as being 'Beautiful as the chance encounter of a sewir
machine and an umbrella on a dissecting table'. Such meetings may see
bizarre, but they do occasionally occur in the real world. From the juxtapositic
in real space of objects with no logical relationship, astonishing visions emerg
as long as the frame holds them in the same shot, creating the sense tha
they are interdependent. 'And why shouldn't a seal make a telephone call?
Fontcuberta seems to ask.

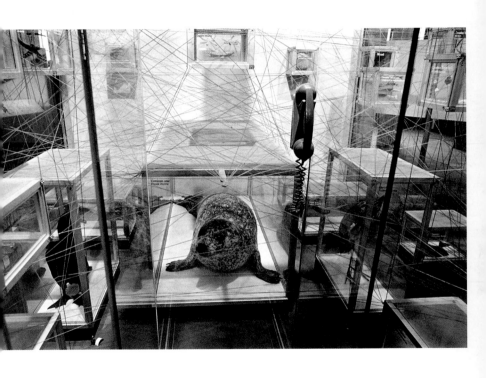

Mont de Venus, Jardì Botànic Cap Roig, Calella, Spain, 1978. At first, we se
a pattern of shapes and motifs within a square, and a circle placed wi
absolute harmony in this perfect space. The light reveals with great precisic
the contrast between the different textures. When we read the title, the imag
acquires a symbolic dimension. However, the gentle humour transcends a
self-conscious artiness that might undermine the image.

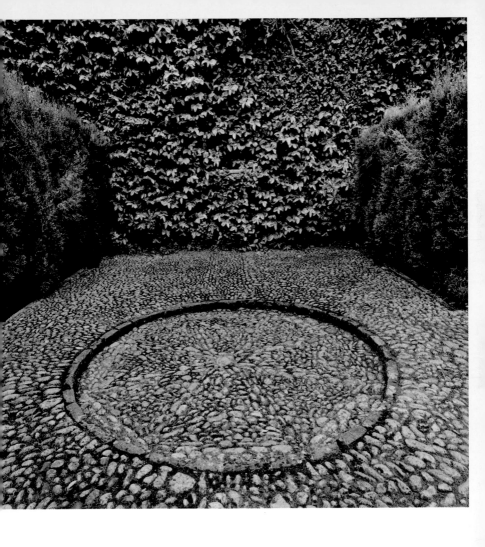

Eagle Dawn, Parc de la Ciutadella, Barcelona, 1979. As in the earlier 'Natura History Museums' series, here, composition becomes a tool for transforming an ordinary situation into a mysterious scene. By dividing the space up according to rules that do not match our normal perception, Fontcuberta enables us to refresh our conditioned way of seeing.

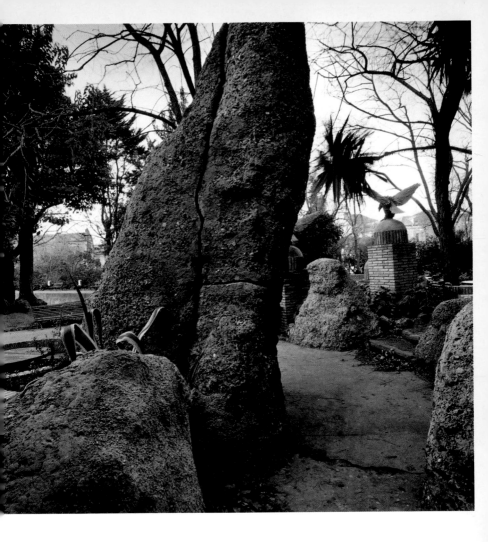

Trucs, Barcelona, 1979. If we agree to observe things differently and in deta (from above or below as practised by the Bauhaus artists and the Russia Constructivists), the world becomes very different, not to say incomprehensibl Photography, then, is no longer a descriptive tool for documenting and explair ing the world, but a question without an answer, a formal proposition linked wit reality but incapable of explaining it.

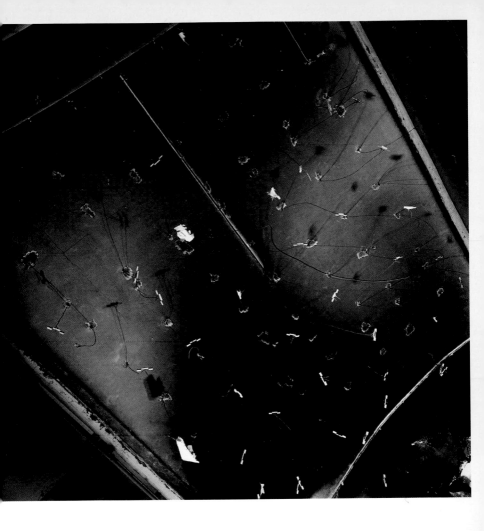

Fallen Angel, Bologna, Italy, 1980. The title focuses our attention on one element (the wing) of a very puzzling image in which the main interest lies in the composition and the balance of masses and forms. But the mere fact of pointing to this element in words does not make the image more intelligible. The artist mischievously tricks us yet again, by making us believe the title is an explanation, and he simply leaves us to observe the subtle play of light in space.

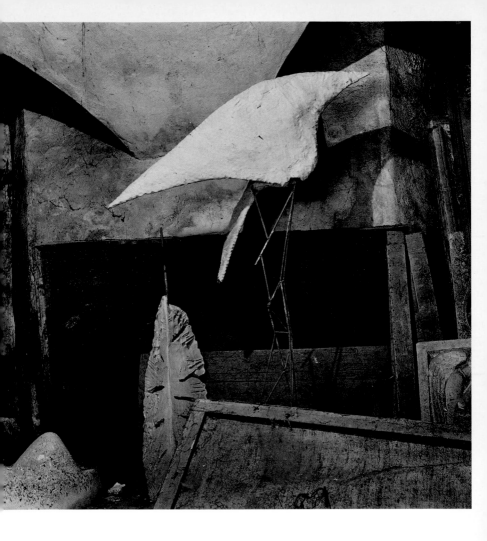

Farm Interior, Llofriu, Spain, 1980. A perfectly ordinary scene (a common-or-garden kitchen, in which there is a fridge with an ornament on the top, and reproduction of a painting on the wall) is made puzzling by the compositic alone; it brings together these two elements, which in reality have no intelligib relationship. Within the frame, and removed from their context, they seem to b linked, but linked in a way that is impossible to determine. One might also see the image contempt for kitsch taste, and the habit we have of accumulating an using objects for decoration.

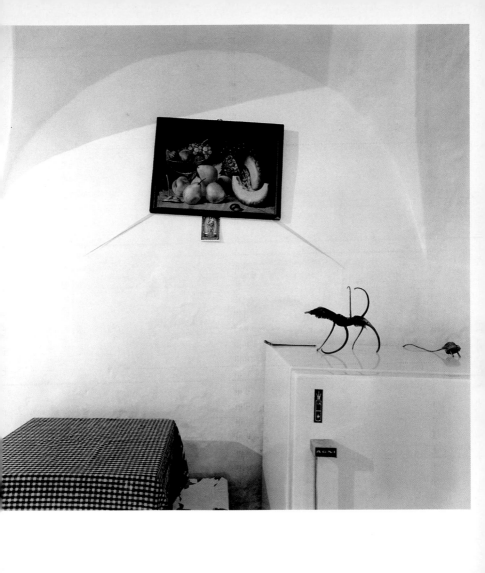

Mendel's Law, Museo Nacional de Ciencas Naturales, Madrid, 1980. Natur
history museums turn nature into an object, conserve it and collect it. Th
nineteenth-century urge to be encyclopaedic led to a ridiculous process
accumulation which, under the pretext of showing us and making us understar
everything, gave us exhibits that were absolutely devoid of sense and qui
unintelligible. The artist has only to emphasize this absurdity through deliberate
perverse centring, and an ordinary display case becomes meaningless. Becaus
of the system it has adopted, and contrary to its own intention, the museum doe
not explain the world, but makes it more opaque and dusty, and fixes it under ou
uncomprehending gaze.

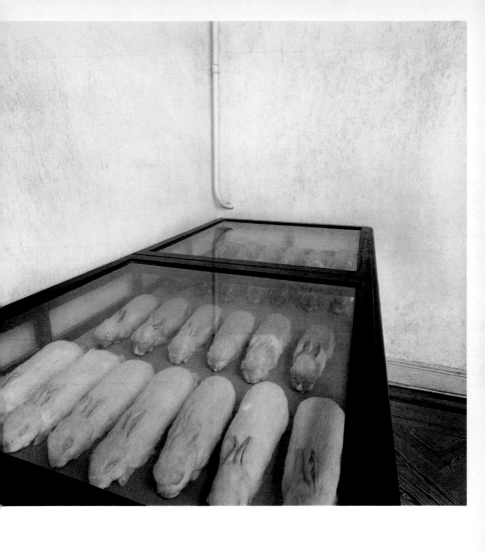

Costa Llobera Garden, Barcelona, 1981. This image draws on the strange surprises offered, if one is alert, by the everyday. Fontcuberta actually found these cactuses, damaged by frost, on the Montjuich hill in Barcelona. But the photographer never contradicts those who think he has fabricated a situation make it more visual, we can only speculate as to the truth.

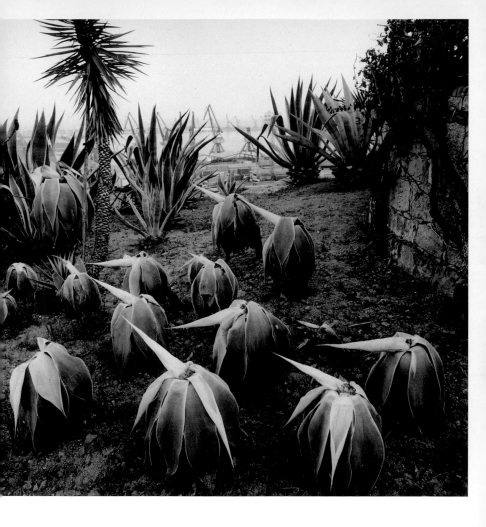

Guillumeta Polipodida, 'Herbarium', Barcelona, 1982. These bizarre plant made from industrial waste and shot in a highly formalist style against white background, are a tribute to the German artist Karl Blossfeldt who, the 1920s, made a series of prints depicting natural forms. Full of humou the image encourages further reflection on the act of perception.

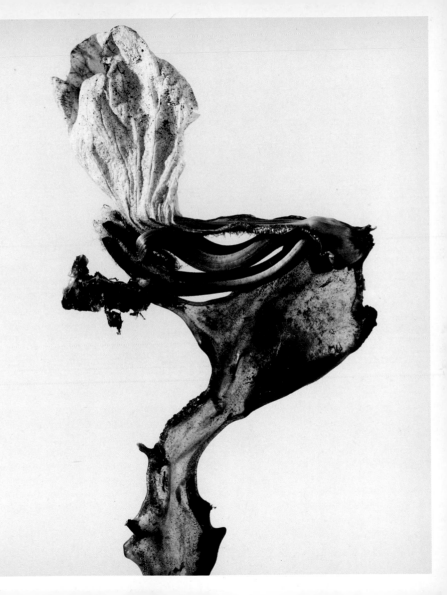

Cala Rasca, 'Herbarium', Barcelona, 1983. This 'plant' has been created with extreme care so that we are initially taken in by the image. This is facilitated our immediate recognition of the familiar, floral element, and by our desire believe that it can actually be found in nature.

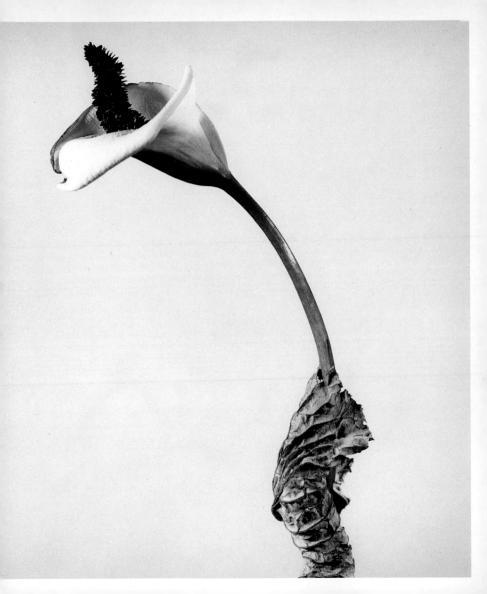

Lavandula Angustifolia, 'Herbarium', Barcelona, 1984. The botanical Lati
name with which Fontcuberta christens this troubling mixture of animal an
vegetable elements is intended to emphasize the serious, 'scientific' characte
of the 'Herbarium' series.

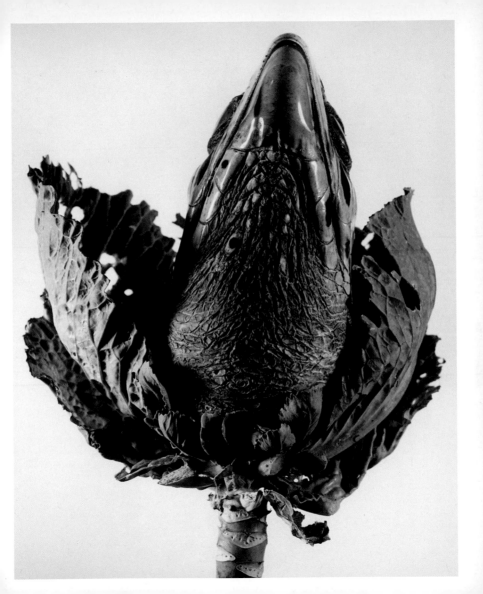

Braohypoda Frustrata, 'Herbarium', Barcelona, 1984.The authenticity of thi
composition is belied by humorous elements such as the accompanying tex
a witty spoof in 'dog' Latin that arranges the material in the same way as th
scientific herbariums in botanical museums.

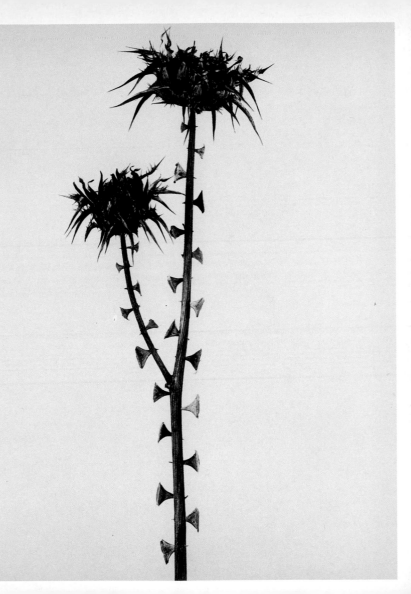

Taxidermist Workshop, Toronto, 1986. Does the zebra have a fourth hoof? W have its limbs been so violently severed? Are we looking at a work by Dami Hirst? Or a bad joke, set up in a zoo? The image, which is strange, unusual a disturbing, retains its air of mystery. It is no more than a visual 'shock' th makes us wonder what it represents, one more puzzle to remind us of the surr alism of the everyday, the world's absurdity, the ineffectiveness of the way m constructs nature, as he tries desperately to represent and understand it.

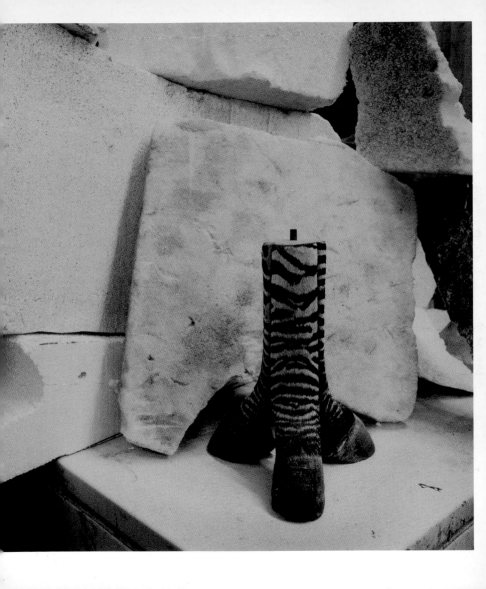

Micostrium Vulgaris, 'Fauna', Barcelona, 1985. Here, Fontcuberta moves fro
plants to animals, adopting the style used for recording the results of a scientif
expedition. This extraordinary, unique 'document' testifies to the importance
field studies, and considerably enriches our knowledge of nature's oddities!

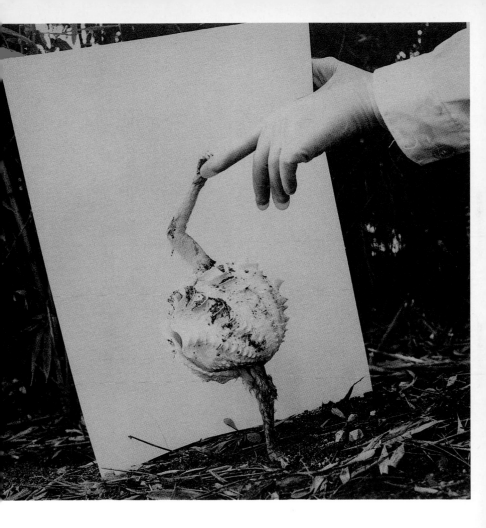

Solenoglypha Polipodida, 'Fauna', Barcelona, 1986. This photograph of a sna with many feet crossing a grassy field takes advantage of the special quality of t evening light.

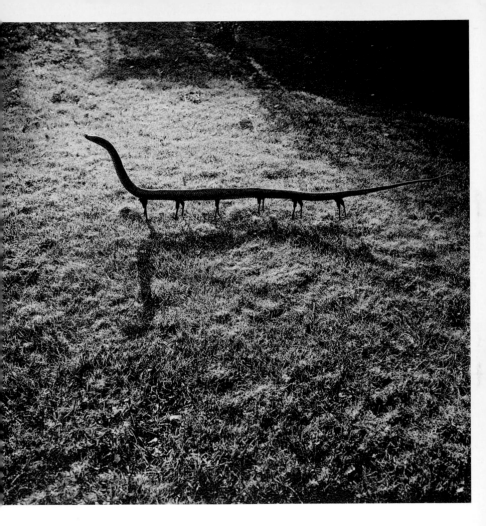

Alopex Stultus, 'Fauna', Barcelona, 1986. This document provides 'evidenc[e]
that animals can mutate and adapt to difficult climatic conditions. In order [to]
withstand cold and snow, the creature, formerly a member of the tortoise fami[ly,]
has grown long front legs, become partially erect, and developed thick fur [to]
enable survival in harsh winters. Unfortunately, nothing is known about h[ow]
it reproduces.

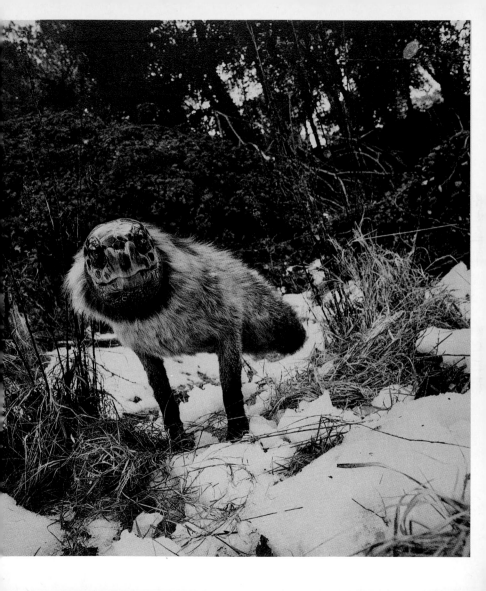

Cercopithecus Icarocornu, 'Fauna', Barcelona, 1987. Contrary to accepte[d] scientific opinion, unicorns have not completely disappeared, but have simp[ly] evolved in order to avoid being hunted down by man, who saw them as magic[al] beasts. The traditional horse with a single horn on its forehead gradually gre[w] smaller, and the development of wings meant that it could escape its pursue[rs] more easily. Its undeniable loss of elegance is compensated for by a great[er] ability to protect itself. The history of this evolutionary process has still to [be] studied and compiled.

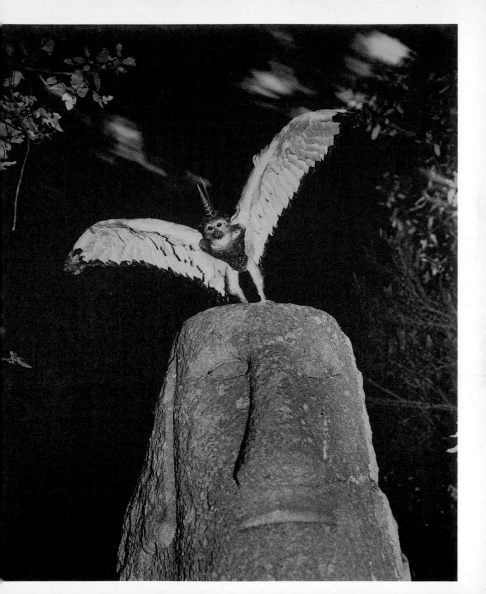

Centaurus Neardentalensis, 'Fauna', Barcelona, 1988. In the visually beauti
and exuberantly humorous series 'Fauna', Fontcuberta questions our credu
with regard to the veracity of photography as evidence, as much as o
naive faith in science as a means to discover more about the world around
In order to deceive us more convincingly, Fontcuberta has artificially ag
these prints and documents; they are blotched, torn, folded and in po
condition. We have the sense that we are looking at indisputably 'genui
archive material, which, because it can be seen, must therefore prove that t
'scientific' demonstration is serious.

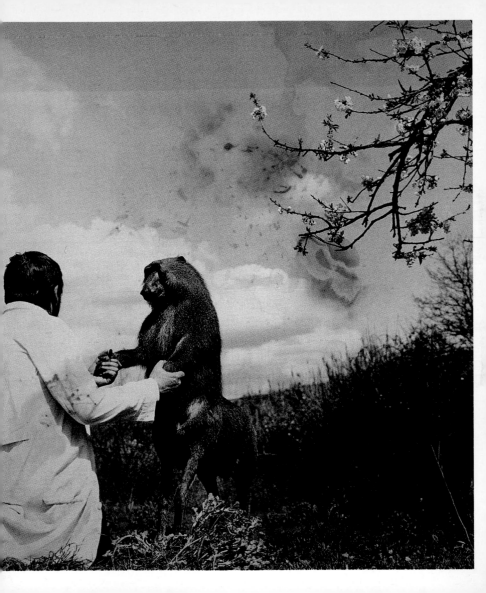

Tyrannosaurus Rex Leg, Museu de la Ciènca, Barcelona, 1989. In a museum,
strange piece of sculpture (which might suggest the work of the French sculptc
César) becomes an object that is both impressive and terrifying. The imag
makes us think the object in the photograph is monumental, but there is no proc
of this. The perfection of the light, which gives the shadow a puzzling qualit
and the apparent simplicity of the centring present us with a museum objec
about which we can know nothing. Hovering between the attractive and th
repulsive, a monstrous object, possibly very small in size, turns into an enigmat
work of sculpture, imbued with the spirit of contemporary art.

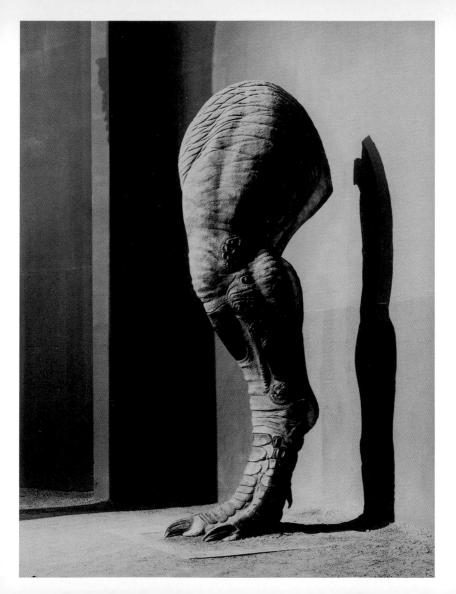

Euphorbia Cereiformis, Barcelona, 1987. Here, the idea of photography as th 'imprint of reality' is taken to its extreme, with an inevitable dash of absurdit In order to emphasize the 'veracity' of the image, after the shot was taken, th cactus was brought into direct contact with the negative, which it ha scratched, as if physical contact could render the image more 'true'.

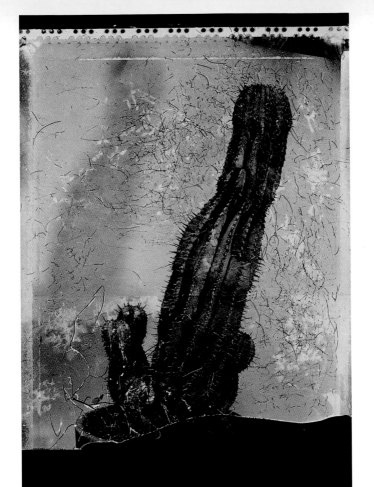

Monadenium Shubei, Barcelona, 1987. The 'frottograms' were produced in mu
larger formats than the preceding series, and a process of heavy toning a
sulphuration gives the prints a rich, almost painterly quality that defines t
series more markedly as 'fine art'. The image is very beautiful, employing sub
and delicate colours, but ironically, the objects represented become increasing
difficult to recognize once they have been in contact with the negative.

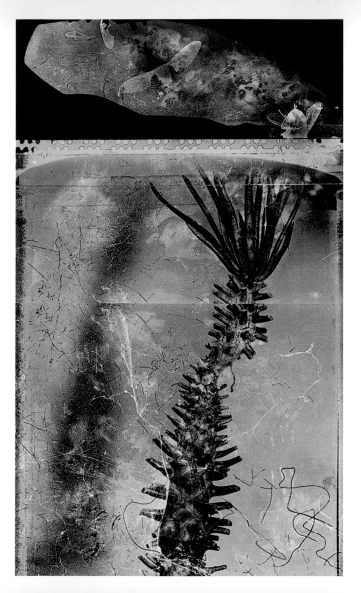

Compared Anatomy IV, Barcelona, 1987. Here, the artist uses collage, but in a entirely new way, to present the clash between different universes, includir the human and animal worlds. The formal beauty of the images (which are sing pieces) both disarm and intensify what is potentially disturbing when di ferent worlds are brought together. Even before genetic modification became cultural preoccupation, Fontcuberta's 'photographic transplants' were alrea questioning the way in which science was in danger of going adrift.

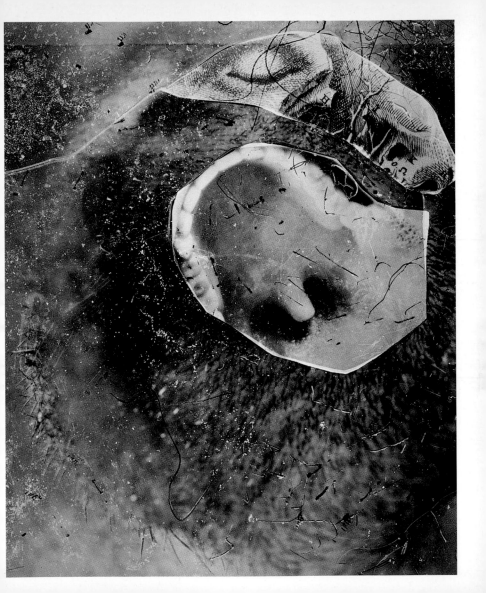

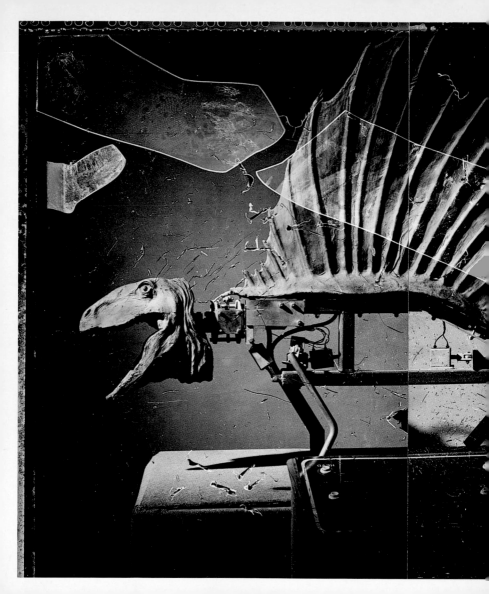

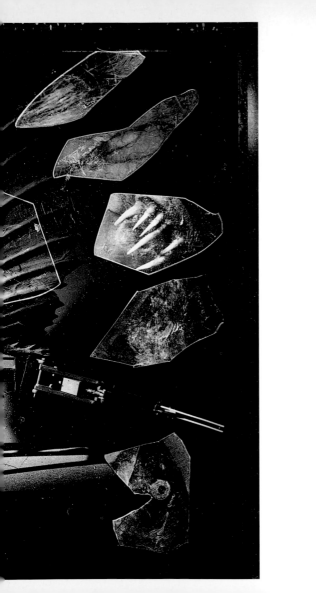

(previous page) Tatlin Dinosaur, Barcelona, 1990. This very large-form
image provides a link with two previous series, 'Natural History Museum'
and 'Fauna'. Looked at carefully, this animal – found in a perfectly respectab[le]
museum – is as strange as the weird and wonderful creations cobbled togeth[er]
for 'Fauna'. The collage method organizes the image-space visually by par[t]
counteracting the allure of the perfect light with which the compositi[on]
is suffused.

Dragon Garden, Barcelona, 1991. The reference to Gaudí is explicit and the r[ich]
toning particularly subtle. Here, Fontcuberta moves towards a highly compl[ex]
exploration of matter. The image declares that the work of the photographer
in recomposing the world after it has been deconstructed at the moment wh[en]
the shot is taken.

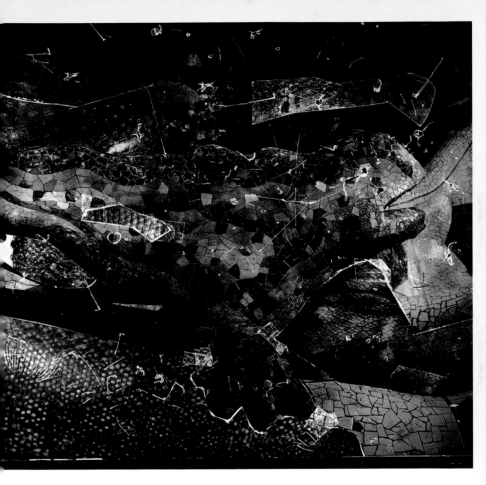

Oriental Genius, Barcelona, 1989. This photograph marks a new stage Fontcuberta's practice by bringing the object represented and its image in direct relationship. Reviving the photogram, a technique invented by Man Ra and Christian Schaad, Fontcuberta makes these photographs witho negatives. Coating the paper (in this case, wallpaper) with emulsion, he rende it photosensitive. In his darkroom he then places real objects (flowers ar birds) on the wallpaper, which retains their imprint alongside the origin representational images.

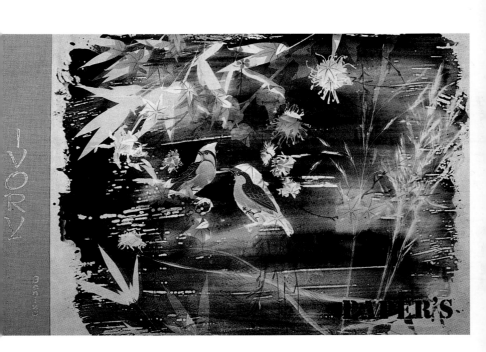

Springtime Exigences, Barcelona, 1991. The process of 'direct' photograp
reduces to a minimum the distance between the object and its image. This wo
encompasses a set of reflections on the motif and its repetition, which are
the more problematic since the imprint of the 'real' plant or flower is supe
imposed on its painted, and therefore interpretative, image. Questions of tr
and false, illusion and repetition, the real and its image, are explored.

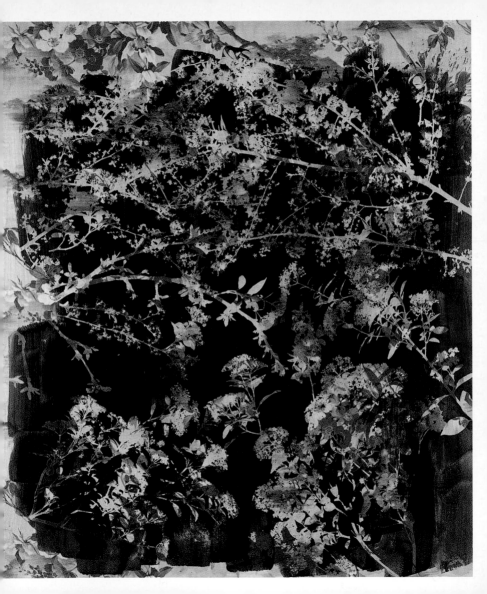

Pinks and Clematis in a Crystal Vase, Barcelona, 1993. Questioning the idea
the motif inevitably leads to questioning the 'decorative' dimension of the visu
arts, especially painting. Here, Fontcuberta took a printed reproduction (the fir
form of representation to be mass-produced) of a painting of flowers by Mane
On to its emulsified surface he placed a crystal vase and real flowers, so th
their images are superimposed on top of Manet's painted representation. The er
result presents three different types of reproductive imagery: Manet's renderir
of a bouquet, its printed facsimile, and Fontcuberta's photographic outline
Which is the 'truest' form of representation? As spectators, we are brought fac
to face with images that do little to help us understand the world.

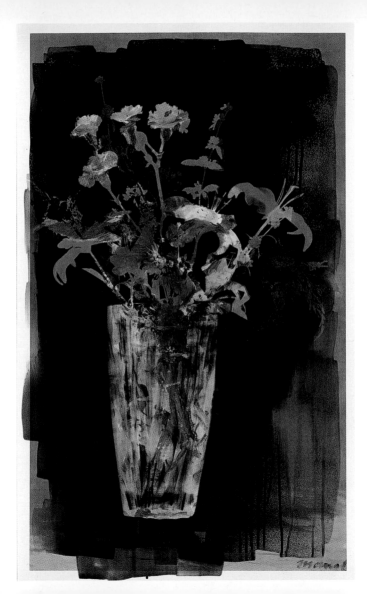

Golden Fish, Barcelona, 1991. Here, Fontcuberta superimposes the photo graphic imprint of fish on the reproduction of a painting of goldfish in a bowl Matisse. Serving as negatives, these fish allow the reproduction to appear, li an optical illusion. The juxtaposition of 'real' fish with the painted reproductio of fish that died long ago leads us to question our helplessness and credulou ness when faced with the natural deceptions of representation.

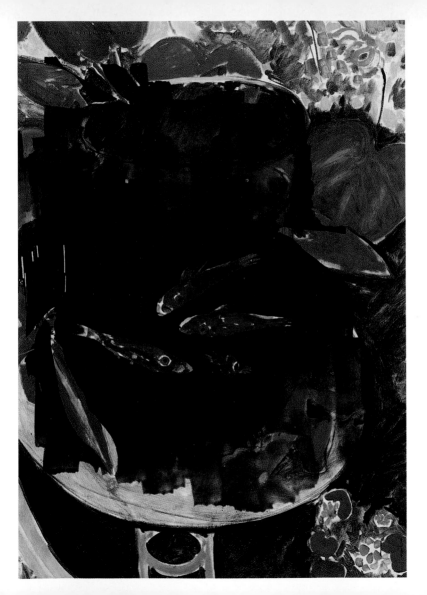

The Dream, Barcelona, 1993. A woman has lain on the image of a dreaming woman painted by Matisse. Her silhouette remains on the photosensitive paper revealing the painting in those places where her body, acting as an opaque negative, has prevented the light from reacting with the silver salts. However, her image was captured in profile, while the one painted by Matisse was three-quarter face. The resulting melded images provide a neat interrogation of Cubism, which, almost a century earlier, had taken the bold step of representing the same object from a number of different angles simultaneously.

Ophelia, Barcelona, 1993. This large-format piece is one of the most visua
stunning of Fontcuberta's 'rayogram' series. The illusion is almost perfect, a
the coincidence of the painted image and its photographic double (applied
contact) is genuinely disconcerting. If it were not for the transparent, phantor
like hand and profile, and the feet, which reintroduce the direct presence of
certain (illusory) reality into the imagery, we would be unable to distingui
between the two representations.

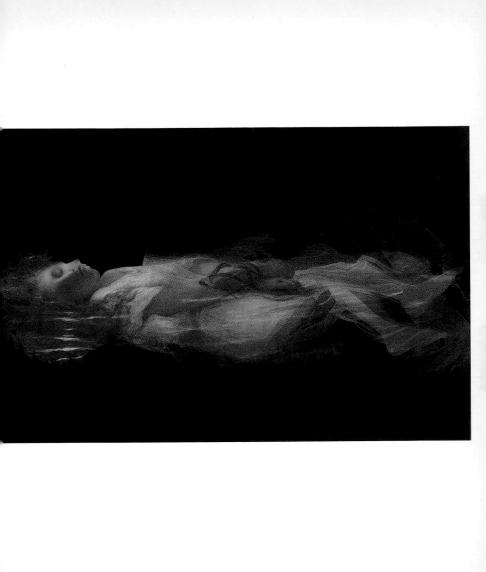

Chicago, 1996. For his 'photogram-chemigram' series, executed in the 1990
Fontcuberta does not use negatives, instead offering a complex reading of th
city by projecting its image directly onto sensitized paper. The struggle betwee
the 'realist' (that is to say, recognizable) presence of the architecture, and th
artist's interventions (the arrangement of forms in the foreground) induces u
to see a new world consisting of a collage of different perceptions.

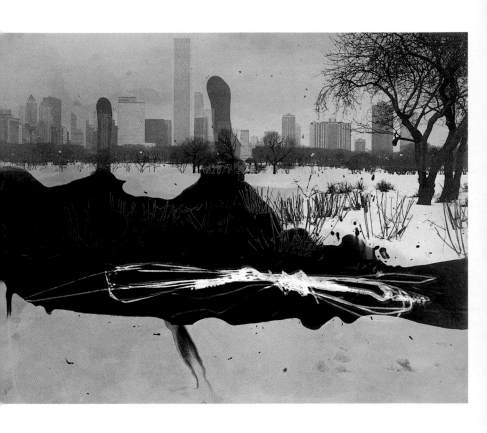

Altos Hornos de Vizcaya, Bilbao, Spain, 1995. The photographic print of t
Bilbao blast furnaces is juxtaposed with photograms of *objets trouvés*. T
varied tones give this highly pictorial composition a strong visual dimension. W
are looking at an image that is far removed from reality, but summons it up wi
great directness. It is a 'photographic picture', in the brown tones which t
artist is particularly fond of, but the easily recognizable details of industri
architecture evoke a version of reality that seems to be floating as if in a drear

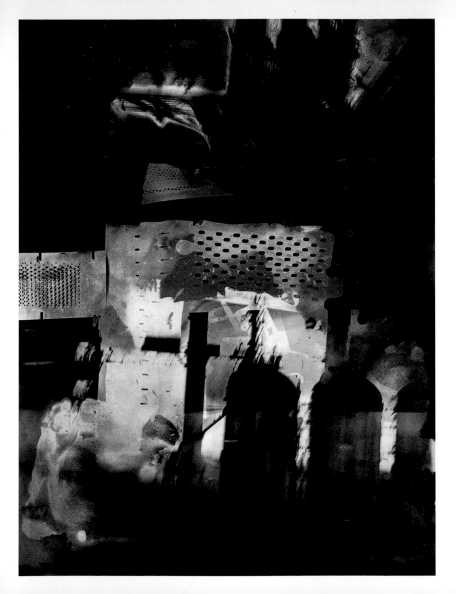

Yokohama Highway, Tokyo, 1996. This further confrontation with the city pu
great emphasis on purely photographic issues. Light seems to come from with
the depth of the blacks to create a work steeped in the photography of the 192
and 30s, recalling the experiments of Man Ray and Moholy-Nagy.

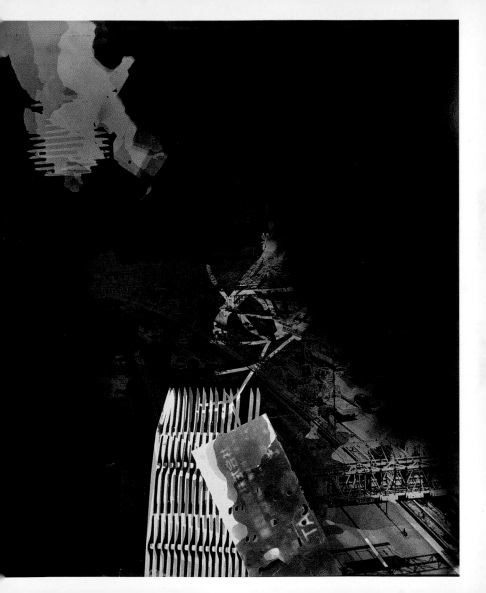

Gasholder from Parkwood Springs, Sheffield, 1997–8. This large, supreme
elegant work establishes a link between the city prints series, the wallpap
series and the motif. The modulation of blacks, greys and whites, the slig
solarization of the urban fabric, and the distinct presence of the branch, use
as a negative to form the white design in the foreground, all work together
create a space of unusual depth. It is particularly successful in suggesting
series of discrete, stepped planes, which do not exist in the real world.

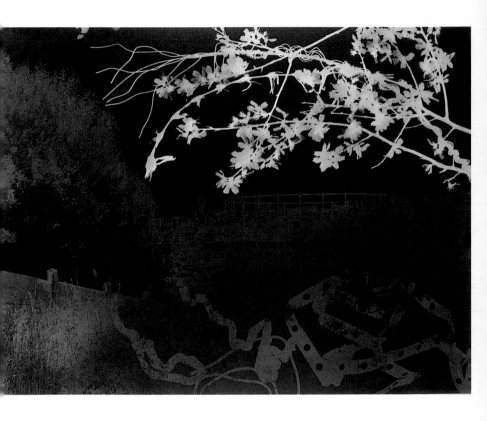

MN 27 Vulpecula (NGC 6853) AR 19h 56,6 min/D+22° 43', 'Constellations, **Barcelona, 1993.** With the series 'Constellations', Fontcuberta returns 'science'. These large-format images resembling the milky way are actua photographs of insects splattered on his car windscreen. The effect is bo humorous and surprising — one cannot help laughing at the idea that squashe mosquitoes can be taken for stars.

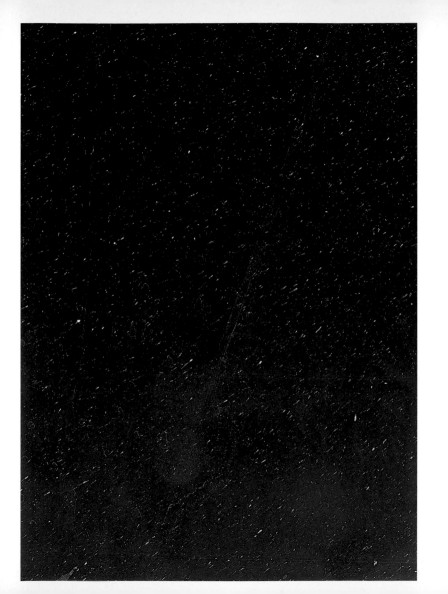

MN 56 Lyra (NGC 6779) AR 19h 16,6 min/D+30° 11', 'Constellations **Barcelona, 1993.** Views of what appears to be a starry sky are accompanied by formidably detailed notes, written in an indecipherable coded language. With his usual sense of humour, Fontcuberta takes pleasure in emphasizing the ludicrous aspects of this pseudo-scientific rigour. Looking at the image, how could one prove that it represented insects, not stars?

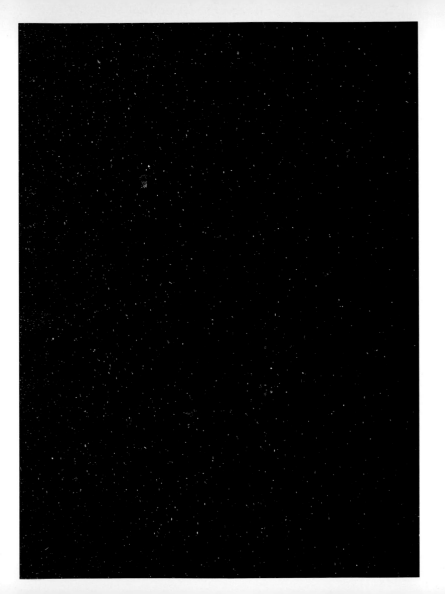

Kappa Boötis (Mags 4,6/4,6 Sen 13,4" AP 236°) AR 14h 13,5 min/D+51° 47

'Constellations', Barcelona, 1993. At 14 hours, 13 minutes and 5 seconds, white streak suddenly crossed the sky. It was not visible to the human eye but was recorded by chance at an observatory. Millions of light years awa an exploding planet has altered the balance of one of the rings of Satur This fact, of which we have only now become aware, could provide scientist all over the world with a better understanding of why there is water on Mar A paper on the subject by Professor Urs Lunaticam will appear next week the journal *Nature*.

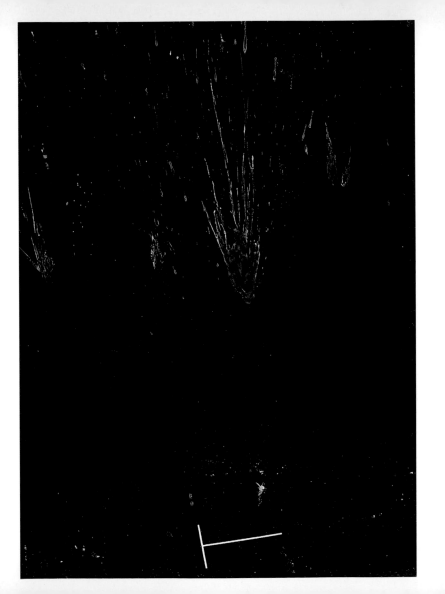

DA II 27-6-98, 'Haemogram', Barcelona, 1998. In his 'haemograms'
Fontcuberta returns to photography without negatives. Or, more specificall
he uses the object he wishes to represent as a negative, this time in colou
First, he asks his friends to provide him with a drop of their blood. Then, usin
this 'original' as he would a colour slide, he makes a print from it. In a sense
it becomes a 'portrait' of the donor.

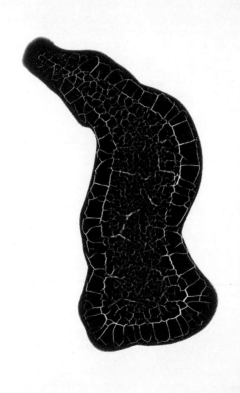

RL 2-10-98, 'Haemogram', Barcelona, 1998. In this unique approach to portraiture, the blood can take an extraordinary variety of forms and colours on the transparent slide. This random image might support the hypothesis that man's distant ancestor was the fish.

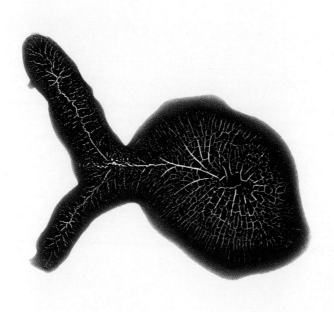

MS 16-7-98, 'Haemogram', Barcelona, 1998. All blood is not of the same colour. Fontcuberta 'proves' this with his relentless 'objectivity' and rigorous methodology. The accompanying fingerprint suggests forensic methodology and police methods that go back to Berthillon and the nineteenth century. It is a reminder that taking blood samples is another way of classifying humanity.

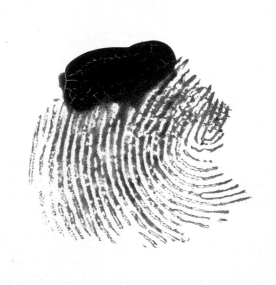

TL-BS 3-5-99, 'Lactogram', Barcelona, 1999. Soon after making the fir[
'haemograms', Fontcuberta began working with another vital bodily fluid in t[
'lactograms' series. Based on the same technical principles, this series came [
against identical issues. When milk is used as an 'original', it does not alwa[
produce the same images. Just as blood is not always red, in photography, milk
rarely white.

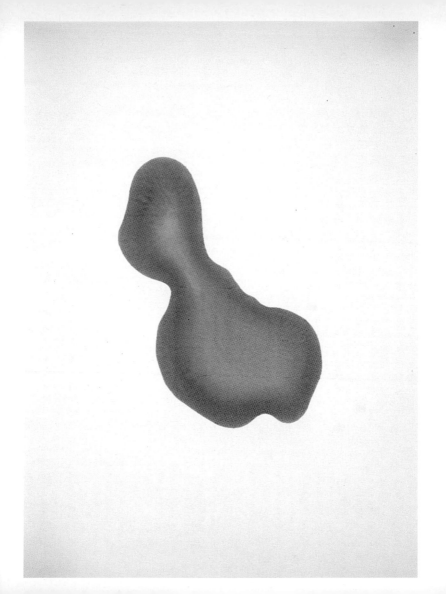

MR-AR 6-5-99, 'Lactogram', Barcelona, 1999. This drop of milk, supplied by o
of the artist's friends, makes us think at first of a pictorial work, a revision aft
the manner of a lyrical abstractionist. Our unease comes when we learn that
was in fact printed from a 'real' drop of human milk. When printed in large form
all that remains is the purely photographic subject matter, which has more
common with painting than with medicine or science. Is it right, then, to speak
these works as 'portraits'? Where should we situate this approach, which, with
rare economy of means, interrogates the very nature of the individual at h
most essential?

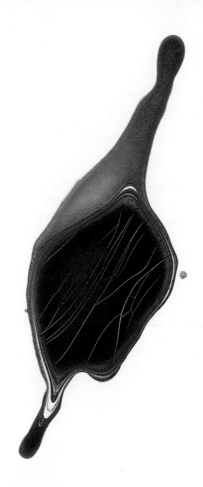

NR-AL 7-2-00, 'Lactogram', Barcelona, 2000. As Roland Barthes has sai
what has been leaves its trace. But the trace will be incomprehensible unless w
are given clues and information in order to interpret it. This image could be t
work of an abstract painter. We should not necessarily take at face val
Fontcuberta's claim that one of his friends gave him this drop of her own milk.

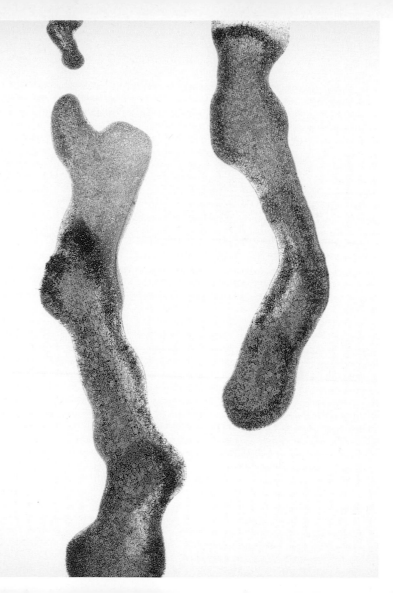

Satanic Verses (Rushdie), 'Semiopolis', Barcelona, 1999. Semiopolis (a play o
the Greek word *semios*, meaning sign, text or writing) tries to explore a wor
based not on the image, but on the text. Texts composed in Braille are trans
formed by light and the way the shot is taken into landscapes that suggest spa
and the cosmos, and have something in common with NASA pictures. And sup
posing the image of the world was based not on photographs but on writte
texts? The idea is both conceptually complex, with constant movement back an
forth between text and image, and visually obvious, part of the contempora
iconographic language of our universe.

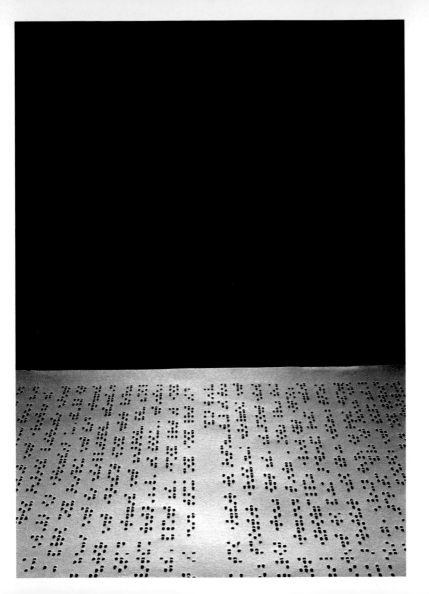

Heart of Darkness (Conrad), 'Semiopolis', Barcelona, 1999. Fontcuberta choice of texts makes up his ideal library; he is here inspired by exampl ranging from Genesis to Proust, Salman Rushdie to Joseph Conrad. It is diffic to assign specific importance to any one of these images, because 'Semiopol makes sense as a whole, bringing photography into dialogue with texts writt over the past 2,000 years. These large-format images, whose words we cann read, declare that no mode of creativity (photography for example) is auton mous, and that it is essential that a dialogue exist between all those who ha something to say about the contemporary world.

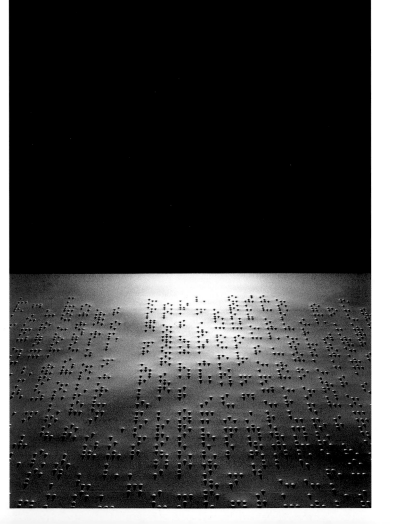

Aleph (Borges), 'Semiopolis', Barcelona, 1999. Fontcuberta's project for a[n] ideal library has, of course, a connection with the 'Library of Babel' of th[e] Argentine writer Jorge Luis Borges, who was blind and for years had access [to] writing through the medium of Braille transcripts. This is perhaps the centr[al] image of the series, and probably the most complex. The 'Library of Babel[,]' which was said to encompass the whole world and our knowledge of it, is [a] dream, just one more illusion, but an illusion that is so exciting that we canno[t] but yield to its appeal.

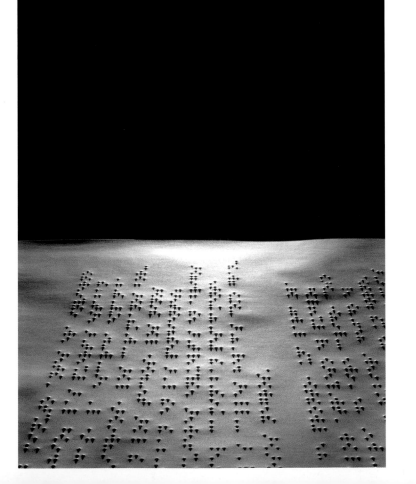

The Origin of Species (Darwin), 'Semiopolis', Barcelona, 1999. This work nod in the direction of Darwin and the science of his contemporaries, which aimed catalogue and classify everything, to impose a 'logical', or 'rational' order on th world that would render it totally transparent and comprehensible. Yet here w are, looking at photographic images of texts we cannot read because they hav been designed for people who cannot see.

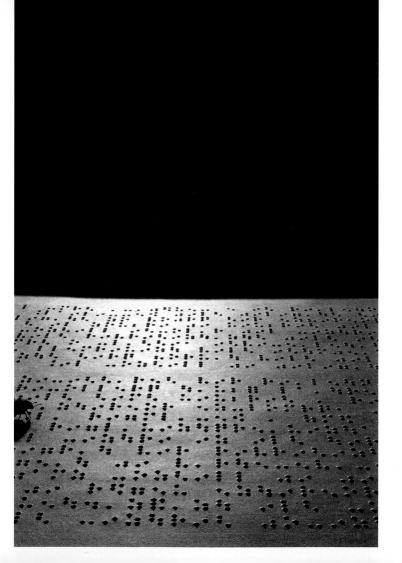

1955 Born 24 February, in Barcelona, where his parents settled just after the Spanish Civil War. His father founded an advertising agency, and through this he is introduced to the world of photography.

1966–1972 Attends secondary school in Barcelona where he becomes interested in photography, encouraged by his literature teacher, a keen amateur photographer who sets up a school darkroom. Has an accident with a home-made explosive which makes using a camera difficult.

1972–1977 Studies Communications at the Autonomous University, Barcelona. Takes up photography seriously and collaborates with political and civic organizations to produce posters and flyers.

1979 Becomes Professor of Photography and History of Photography, Faculty of Fine Arts, Barcelona University, a department he helps found.

1980 Founder member and editor of *Fotovision*, international publication devoted to photography and the visual arts.

1982 Founder member of 'Photography Springtime', a biennial event.

1985 Publishes *Herbarium*. Exhibition 'Herbarium' held at George Eastman House, New York, Galeria Redor, Madrid, Shadai Gallery, Tokyo and Hochschule der Künste, Berlin.

1986 Leaves his university professorship to devote himself to creative projects and theoretical writings.

1987 Publishes *Fauna*. Awarded the David Octavius Hill medal by the Foto grafisches Akademie GDL, Germany.

1988 Has a daughter, Judit, with curator and critic Marta Gili. Exhibition 'Fauna' at Photographer's Gallery, London and Museum of Modern Art, New York.

1990 Visiting artist and professor at the Art Institute, Chicago. Exhibition 'Paper Gardens' held there.

1992 Publishes *Historia Artificial*, the most comprehensive publication of his work to date. Exhibition 'Fauna' at Parco Gallery, Tokyo and Friends of Photography, San Francisco.

1993 Resumes regular teaching as associate professor at the Universitat Pompeu Fabra, Barcelona.

1994 Made Officer of the Order of Arts and Letters by the French Ministry of Culture.

1995 Exhibition 'The Wonders of Nature', Museum Rupertinum, Salzburg, Austria.

1996 Artistic director of the International Photography Festival, Arles.

1997 Publishes *Sputnik*. Exhibition 'Sputnik' at Fundación Arte y Tecnología.

1998 Awarded the National Prize in Photography by the Spanish Ministry of Culture.

1999 Exhibition 'Sputnik' at Museum of Fine Arts, Fukui, Japan and Museu Nacional d'Art de Catalunya, Barcelona.

2000 Exhibition 'Twilight Zones', Zabriskie Gallery, New York. Continues to lecture and give seminars at the Estudis de Comunicacio Audiovisual, Universitat Pompeu Fabra, Barcelona.

Photography is the visual medium of the modern world. As a means of recording, and as an art form in its own right, it pervades our lives and shapes our percep

55 is a new ser~~MAR 1 2~~ **D** *produced, '~oks* that acknowledge and celebrate a... *styles* and all aspects of photography.

Just as Penguin books found a new market for fiction in the 1930s, so, at the start of a new century, Phaidon **55**s, accessible to everyone, will reach a new, visually aware contemporary audience. Each volume of 128 pages focuses on the life's work of an individual master and contains an informative introduction and 55 key works accompanied by extended captions.

As part of an ongoing program, each **55** offers a story of modern life.

Joan Fontcuberta (b.1955) became a photographer in the 1970s. Coming from the tradition of Spanish Surrealism, he creates elaborate photographic hoaxes that challenge and provoke, forcing us to re-examine the relationship between photography and reality. The only reliable information a photograph can tell us, Fontcuberta believes, is that it is just that – a photograph.

Christian Caujolle is a writer and photography critic. He has written several books, including monographs on William Klein, Peter Beard and Sebastião Salgado. He is also Director of the Paris photographic agency VU.

Phaidon Press Limited
Regent's Wharf
All Saints Street
London N1 9PA

Phaidon Press Inc.
180 Varick Street
New York NY 10014

www.phaidon.com

First published 2001
©2001 Phaidon Press Limited

ISBN 0 7148 4031 9

Designed by Julia Hasting
Printed in Hong Kong